STRENGTH

Featuring Frida Kahlo

With words by Ann Kay

This is a FLAME TREE Book

FLAME TREE PUBLISHING
6 Melbray Mews, Fulham,
London SW6 3NS, United Kingdom
www.flametreepublishing.com

First published 2019

19 21 23 22 20
1 3 5 7 9 10 8 6 4 2

ISBN: 978-1-78755-679-9

A copy of the CIP data for this book is available from
the British Library.
Printed and bound in China

STRENGTH

Featuring Frida Kahlo
With words by Ann Kay

THOUGHTS TO INSPIRE & MOTIVATE

**FLAME TREE
PUBLISHING**

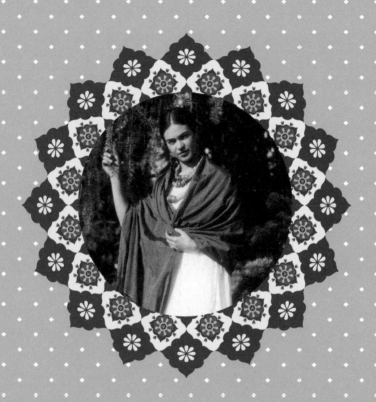

STRENGTH

Featuring Frida Kahlo

With words by Ann Kay

Strength: Thoughts and Ideas

Quotes from Frida and many other inspirational
women from science, literature and popular culture

Frida Kahlo: An Inspiration

An insight into her motivations, art and
techniques by Ann Kay

My painting carries with it
the message of pain.
Frida Kahlo

Think like a queen. A queen is not afraid to fail. Failure is another stepping stone to greatness.

Oprah Winfrey

The only thing I know
is that I paint because
I need to, and I paint
whatever passes through
my head without any other
consideration.

Frida Kahlo

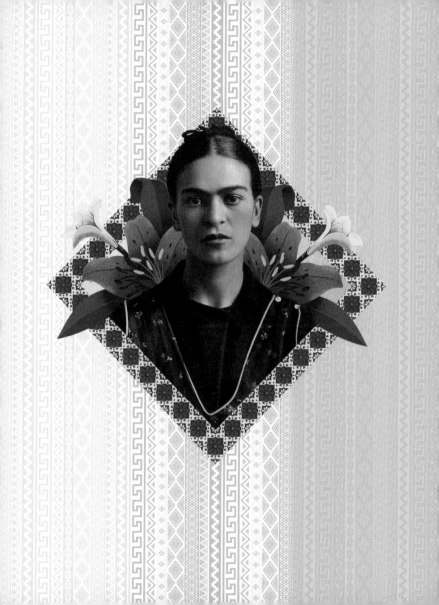

I'll paint myself
because I am so
often alone, because
I am the subject
I know best.

Frida Kahlo

Whatever happens to you belongs to you. Make it yours. Feed it to yourself even if it feels impossible to swallow. Let it nurture you, because it will.

Cheryl Strayed

To paint is the most terrific thing that there is, but to do it well is very difficult.

Frida Kahlo

I think I will be able to,
in the end, rise above the
clouds and climb the stairs
to Heaven, and I will look
down on my beautiful life.

Yayoi Kusama

My paintings are the
most frank expression
of myself, without taking
into consideration either
judgements or prejudices
of anyone.

Frida Kahlo

You know what's really cool? Wake up every morning, decide what you feel like doing, and do it.

Amanda Palmer

Feet, what do I need you for
when I have wings to fly?

Frida Kahlo

I think that little by little
I'll be able to solve my
problems and survive.

Frida Kahlo

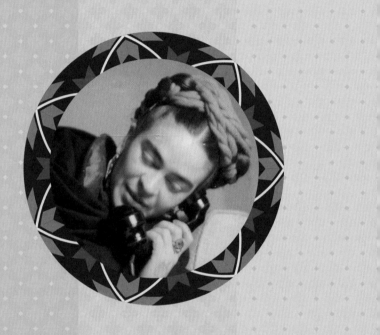

It's been kind of extreme –
people either love it or they
don't like it at all – and I
think that's a good thing.
It's my first art project where
there's not a middle ground.

Tatyana Fazlalizadeh

I used to think I was the strangest person in the world, but then I thought, there are so many people in the world, there must be someone just like me who feels flawed and bizarre in the same ways I do. I would imagine her, and imagine that she must be out there thinking of me too. Well, I hope that if you are out there and read this, know that, yes, it's true I'm here, and I'm just as strange as you.

Frida Kahlo

No one can make you
feel inferior without
your consent.

Eleanor Roosevelt

You don't get anything for nothing. Everything has to be earned, through work, persistence and honesty.

Grace Kelly

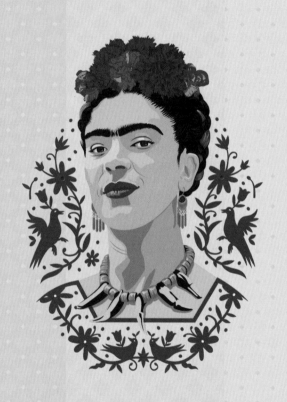

I wish I could do whatever I liked behind the curtain of madness. Then: I'd arrange flowers, all day long, I'd paint; pain, love and tenderness, I would laugh as much as I feel like at the stupidity of others and they would all say: 'Poor thing, she's crazy!' (Above all I would laugh at my own stupidity.) I would build my world which, while I lived, would be in agreement with all the worlds.

Frida Kahlo

The world is changing, I said. It is no longer a world just for boys and men.

Alice Walker
'The Colour Purple'

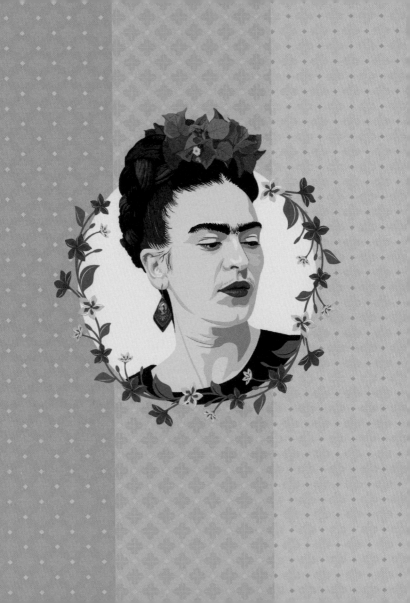

My blood is a miracle that,

from my veins, crosses the

air from my heart to yours.

Frida Kahlo

Take a lover who looks
at you like maybe you
are magic.

Frida Kahlo

You deserve the best, the very best, because you are one of the few people in this miserable world who remain honest with others and that is the only thing that really counts.

Frida Kahlo

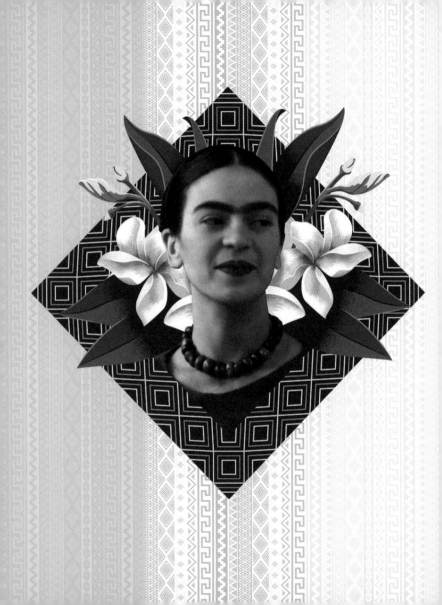

I'm not afraid of
storms, for I'm learning
how to sail my ship.

Louisa May Alcott
'Little Women'

I would give you everything that you never had, and even then you'd know the wonder that is power to love.

Frida Kahlo

What makes you different or
weird, that's your strength.

Meryl Streep

The good news is that you don't know how great you can be! How much you can love! What you can accomplish! And what your potential is!

Anne Frank

The most common way
people give up their power
is by thinking they don't
have any.

Alice Walker

Your word travels the entirety of space and reaches my cells which are my stars then goes to yours which are my light.

Frida Kahlo

I believe in being strong
when everything seems to
be going wrong. I believe
that happy girls are the
prettiest girls. I believe that
tomorrow is another day,
and I believe in miracles.

Audrey Hepburn

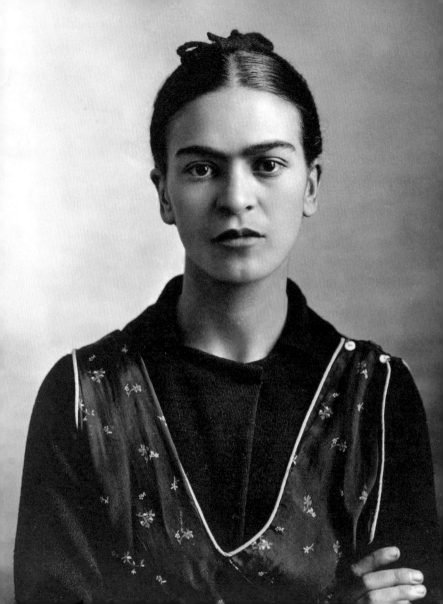

I warn you that in this picture I am painting of Diego there will be colours which even I am not fully acquainted with.

Frida Kahlo

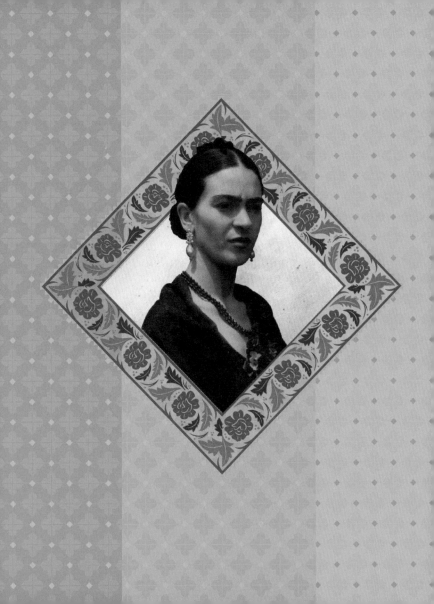

You took me in and
gave me back broken
whole, complete.

Frida Kahlo

If you're offered a seat on a rocket ship, don't ask what seat! Just get on.

Sheryl Sandberg

Nothing is absolute. Everything changes, everything moves, everything revolves, everything flies and goes away.

Frida Kahlo

There is nothing more

precious than laughter.

Frida Kahlo

At the end of the day, we can endure much more than we think we can.

Frida Kahlo

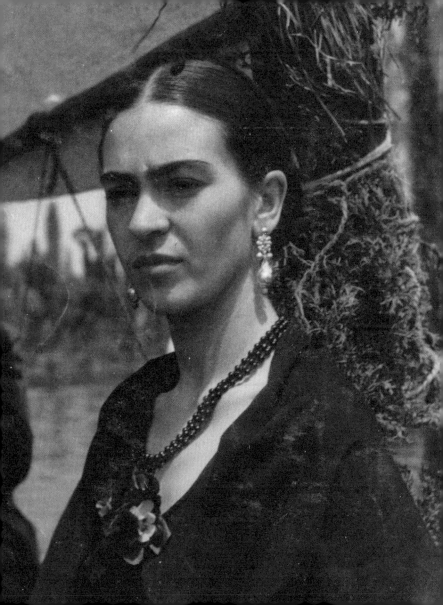

A desire to be more human, to be more normal, that's what pushes me, these days – but as someone said the other day. 'Trace, you're going to have to face facts. You and normal parted a long, long time ago.'

Tracey Emin

Only one mountain
can know the core of
another mountain.

Frida Kahlo

One child,

one teacher,

one book,

one pen can

change the world.

Malala Yousafzai

By doing the work to love
ourselves more, I believe we
will love each other better.

Laverne Cox

I am not sick. I am broken.

But I am happy to be alive

as long as I can paint.

Frida Kahlo

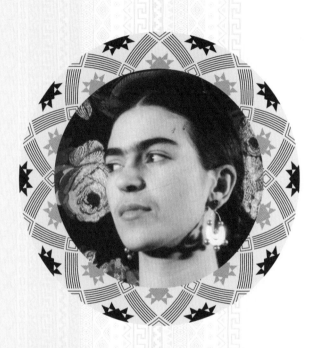

Pain, pleasure and death are no more than a process for existence. The revolutionary struggle in this process is a doorway open to intelligence.

Frida Kahlo

I love to look at art, I love to look at paintings, and I almost feel like the experience isn't complete until I've made something of my own.

Cecily Brown

Your feminist premise
should be: I matter.
I matter equally. Not 'if
only.' Not 'as long as.'
I matter equally.
Full stop.

Chimamanda Ngozi Adichie

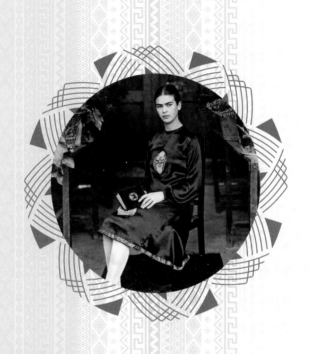

Beauty and ugliness are
a mirage, because others
end up seeing what's
inside of us.

Frida Kahlo

Painting is, I think,
inevitably an archaic activity
and one that depends on
spiritual values.

Bridget Riley

Life is either a daring

adventure or nothing.

Frida Kahlo

The pain is not part of
the life, but can be
converted into life itself.

Frida Kahlo

The most important part of
the body is the brain.

Frida Kahlo

Don't let anyone speak
for you, and don't rely on
others to fight for you.

Michelle Obama

What would I do

without the absurd

and the fleeting?

Frida Kahlo

The most important thing for everyone in Gringolandia is to have ambition and become 'somebody,' and frankly, I don't have the least ambition to become anybody.

Frida Kahlo

People always say that I didn't give up my seat because I was tired, but that isn't true. I was not tired physically... No, the only tired I was, was tired of giving in.

Rosa Parks

Sometimes I prefer to talk
to workers and bricklayers
instead of those stupid
people calling themselves
educated.

Frida Kahlo

The devil is blonde and his blue eyes, like two stars fired love, with his tie and red panties. I think the devil is lovely.

Frida Kahlo

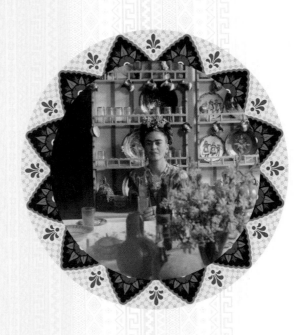

A lot of what I make has to do with a determination to go in there and be okay with just not knowing what's going to come out.

Rosy Keyser

Frida Kahlo: An Inspiration

Mexican painter Frida Kahlo was a woman of powerful conviction and passions. Strikingly personal and boldly coloured work bears witness to a life that was far from easy, but faced with a bravely honest determination. Her art was frequently shockingly frank and troubled; she herself was an authentic individual who often flouted convention. These qualities have made her a beacon of liberation.

Frida's part-central European, part-Mexican parentage shaped her worldview and fed the constant enquiry about identity seen in her work. Born in Coyoacán, Mexico City her early years were

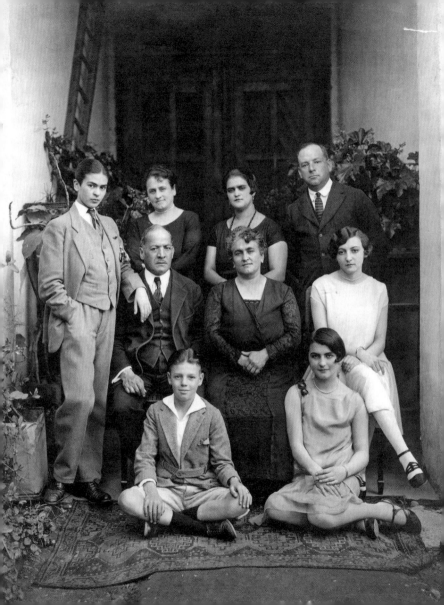

marked by physical trauma. First came childhood polio and then a devastating bus accident in 1925, when she was aged 18.

Both left her with lifelong physical problems and pain but facing them must surely have fuelled her professed eagerness to grab life. Importantly, it was while in bed at home, recuperating from the bus accident, that she began painting.

Artistic Influences

Frida's artistic eyes were opened early on, while helping out her professional photographer father, whom she adored. Her approach and subject-matter were also shaped by her long, intense and

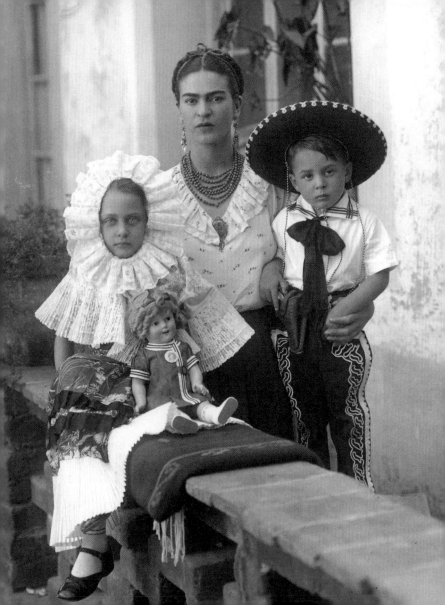

famously tempestuous relationship with Diego Ribera – the celebrated Mexican muralist 20 years her senior, whom she married twice and whose passions for art and left-wing politics she shared.

Frida read widely on art history and admired many established masters, from Sandro Botticelli to Hieronymus Bosch – the former influence evidenced in the strong sense of line and composure of some of her portraits and the latter in her threads of surrealist fantasy. In fact, Frida was often seen as a modern Surrealist, but she was unhappy with the label, feeling that what some saw as 'fantasy' was simply reality to her. Another factor that fed into her work was indigenous 'Mexicana' culture – seen in the flamboyant form of Tehuana costume that she often

wore, as well as the vivid colours and often naïve style of her painting, suggestive of local folk art.

Making Her Art

Frida's works were often small and included painting in oils on metal sheeting, creating pieces akin to traditional objects of devotion. She also took the pre-Columbian style of strong and earthy hues used by Diego and made it her own.

Frida painted on until the premature end of her life in her late 40s. She even attended one exhibition of her work on a bed, holding court with her visitors. This echoed a habit of overcoming difficulty that had started long before.

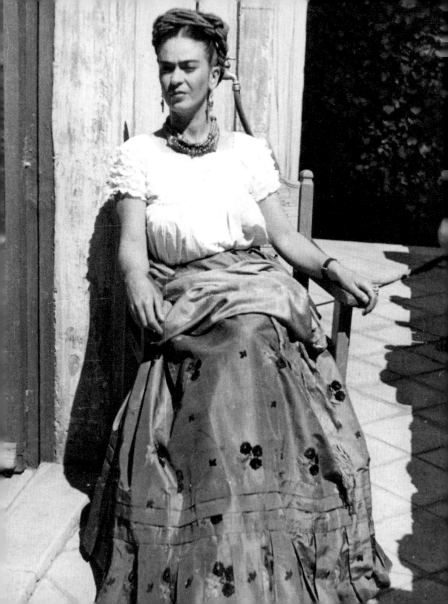

Lasting Legacy

Perhaps Frida's greatest influence, theme and legacy was herself, the subject she said she knew best. Fittingly, she is now chiefly celebrated for the self-portraits that make up much of her output – characterized by that steady gaze that seems to seek the truth of everything.

Frida dared to show us what it was to be a woman, and one in pain, but in a way that transcended gender divisions to open up a dialogue about what it was to be a complex human being.

THOUGHTS TO INSPIRE & MOTIVATE